A CONSCIOUS PEACE

My iPhone Journal

Ruchi Rai

Published by Ruchi Rai
California, U.S.A.

https://www.facebook.com/ruchi.rai.7315

ruchiprai@gmail.com

To my boys, With love

The dedication is in my very being
And also in my writing

Contents

Timeline

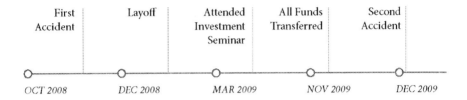

First Accident	Layoff	Attended Investment Seminar	All Funds Transferred	Second Accident
OCT 2008	DEC 2008	MAR 2009	NOV 2009	DEC 2009

Preface

Sent: Monday, November 17, 2014 8:53 AM
Subject: These notes that

THESE NOTES THAT I am sharing are glimpses into my life. I've been assailed by doubts and apprehension and been a closed book to the world— for the longest time!

My "cover up" was my relief. Ironically, today, my outpouring is even more so.

The unburdening is tremendous. It came in a rush. Words tumbling over each other in just a couple of weeks. And then, a trailing thought or two. . . .

Now, my shoulders feel lighter, and I can straighten up.

The thoughts and the confiding came in random order, rather like glowworms at times, and, at others, it was like an oppressive gag from which I had to free myself. I'm taken aback as I read several of the pieces. I have no recollection of writing them. Some of them make me choke up.

Strangely, the writing has been a release. I feel that I have actually been able to stand up to some of my "ghosts" for the first time ever. Some dissolve in a wraithlike manner.
Others try to push me down. . . .

1

All of the writing has taken place on this iPhone. Its silent acceptance has given me confidence, and an untitled folder has kept my confidences safe.

I've tried to bring some semblance of order to the pieces. I have included their dates and time stamps to identify them. As much as possible, I have tried to share them "as is."

I respect each for what it tries to convey, both at and in its own time and in its own way.

Prologue

Sent: Monday, October 13, 2014 7:26 PM
Subject: We build shells

WE BUILD SHELLS around ourselves. Shells that keep others out and keep our insecurities hidden.

The more fragile we feel, the more we curl up inside them. Rather like a snail. It withdraws into what it hopes is a safe haven.

Lucky snail! Little does it realize it is just as weak, just as vulnerable. A careless trampling foot, a sickening crunch, and its fate is sealed!

But it lived its life comfortably, unaware of the precious little protection its shell actually afforded it!

So do we continue in our lives, feeling confident if not invincible, believing that the drastic things in life happen to others, the less ordinary people.

Our ordinariness is our biggest reassurance to ourselves. We feel comfortable that we are part of a crowd and will ride the wave of life with the rest, a series of ups and downs, until we meet the shore.

And then, a gentle lapping. . . .

It is this complacency, perhaps, that is our biggest undoing, that lulls us into

a sense of security, a warm blanket, a safe shell.

But our defenses are fragile. They get crushed, sickeningly so, and leave us exposed and devastated.

And then we need to reinvent ourselves and reinstate ourselves in the world.

Part I

EMERGING FROM THE WRECKAGE

Sent: Wednesday, October 1, 2014 5:30 PM
Subject: I lay there

I LAY THERE on the pavement on a chilly December afternoon.

Extricated from the tangle. Time and its passage had no consequence.

When they reassured me that a crane was coming to lift the truck off me; when they said it was doing so; when they tried to break the windshield, blow by blow, and it rained glass on my face; when they tried to drop in a cold, heavy metal chain (the links of which touched my thigh) to pull out the steering wheel, but there was no gap; when they cut a hole, I believe, near my feet to try to access me, cutting sounds in metal, sounds that would have made my skin crawl and my teeth feel cold, rather like the grinding of metal on concrete. But they were too "external" to me then.

Finally, they broke the armrest, the divider between the driver and the passenger. It was jagged plastic, and the person who had been keeping me propped up had to move out and let me prop myself up on my hand again— on the broken glass. More glass went into my right palm as they tried to pull me out through the opening on the right.

My legs were stuck between the steering wheel and my seat. They had to pull me hard and continue 'til the flesh "gave" and they could drag me out, bit by bit.

That felt impossible, and it hurt. The jagged plastic of the divider scraped and remained relentlessly firm, and the glass was like a carpet burn.

"It hurts!" I protested.

The practical and firm response was, "Let's get you out first. We'll worry about the injuries later."

Laid down on what might have been a stretcher under a grey drizzle. The next thing I knew my clothes were being cut off. Multiple pairs of hands and scissors. They were cutting the clothing off each limb simultaneously!

As I listened to them rip through my pant legs and my jacket, I recall thinking that their scissors must be very sharp. . . .

Within moments I was lying there on the freeway, stark naked. Faces peering down at me, blocking out the sky.

My shocked and urgent protest went unheeded. Modesty was the least of their concerns. They needed to see what injuries I had.

"Let us do our job."

Those voices brooked no argument.

I was helpless. Hopeless.

My shame probably swamped out the physical pain I was experiencing.

Warm tears escaped the corners of my eyes. For the first time in all that trauma, I was breaking down.

Perhaps fainting and being unconscious can offer an escape from harsh reality. . . .

The fact that I was fully aware of myself and my surroundings allowed me to retain control, to plead that my son be picked up from school and to get the message out to my family.

All the moments, sounds, sensations, fears . . . doubled and tripled up, one on top of another, thoughts and apprehensions and a desire to escape, all jostling with each other for all of that time.

There was a point when I just wanted to sleep—trapped inside that car, on my side, bleeding, hot oil pouring on me, glass and all. I wanted to doze off, but fear wouldn't let me. I had to be in charge. I didn't have the luxury of letting it all be.

And then, after a while—I don't know how long—this wonderful gentleman crawled in, reached in next to me, and tried to keep me propped up. I think he said his name was Mike. He told me to go to a happy place, asked me how old my son was, what sports he played. I remember telling him that he played water polo. Ironically, it was the aftermath of this accident that made that sport a thing of the past for him.

They tried to put in IV drips—two of them—but they could reach only enough of me to put in one. They were all so kind, so concerned.

"Mike" even held an orange net vest in front of my face when the glass was pouring down on us—a little detail that showed his compassion. I never saw his face. . . .

When the crane came and tried to lift the truck off, I recall someone shouting to him. I don't recall the exact words, but the meaning was clear: *Watch out!* I understood the warning. He had to be ready to move out should the truck become dislodged for some reason

Mike responded with something like, "Got it".

I sensed that he shifted himself a little more out of the opening on the right, where they had removed the passenger door to reach me.

And it dawned upon me, *He'll leave me if things go wrong and I get crushed. Leave me to die. Just like that. . . .*

I felt nothing. No panic, no accusation, no expectations.

I remember repeating that my son needed to be picked up.

I knew Mike cared.

I WANTED TO sit up, to clutch the blanket around me, hold it close.

I was in the ambulance.

I was out of the car—mangled and tortuous but still familiar—and into unfamiliar and menacing surroundings.

And I was in control of . . . nothing! Powerless, for the first time. Gripped by sheer panic.

I had no clothes on. Nothing under it. It felt prickly and grey, as sharp as the cold that was in my bones. Sharp, cold bones, prickly skin, rough blanket, and it was all closing in. The roof of the ambulance—it was all closed in!

I had to sit up, but they wouldn't let me.

Bottles of fluid above me.

"You'll feel a pinprick."

A heads-up for needles, injections, medical stuff. I didn't need that heads up. I had already been infiltrated. I had glass pieces digging into my hand. More pieces had forced themselves in as I was pulled out—deliberately.

Needles didn't matter. I was beyond caring about pain. I just needed to sit up, but they wouldn't let me!

Two men, I think, consulting each other. One was speaking to me.

"We are 'red hot'," he said. "That means we will get you there fast and that people are waiting at the hospital, the trauma center, to take care of you. We'll be there in no time."

My brain had dulled. I understood I was being reassured, that this person was trying his best, but it didn't have any effect on me. I just wanted to sit up and have this awful coldness go away, the starkness under the stiff blanket. Get my life back and move on.

I heard that my "peripheral pulse" was . . . slow? Faint? Missing? Words and questions but no clear thought. And then the question.

"Are you having difficulty breathing?"

I didn't know. I had no clue what was happening to me. I, who had been so much in control of myself in the car for more than an hour and a half, was now helpless, and that was unnerving. I had no grip. I couldn't help them. "I don't know."

He thought my lungs were collapsed.

He came to my right and told me to be ready for a pinprick. That one hurt. It was not a pinprick! It felt like a garden hose had been pushed in between my ribs, metal casing and all. It was somewhere on the right side of my rib cage.

Capillary tubes that he had tried to insert to help my . . . lungs?

Later, in the trauma room, I saw doctors looking at something next to my bed. Clicking their tongues and shaking their heads and whispering to each other.

Just how bad a state was I in?

Then I turned my mind to more important things, to have them place a call. My son needed to be picked up from school.

It must have been a monitor of sorts. They must have seen the liver injury, an added complication and one that could have been avoided. The paramedic had put the capillary tube into my liver by mistake. He had been trying to do his best. He cared. I heard it in his words, in his voice. Committed—thinking of nothing save me and about how to save me.

I was in the ICU when a man in a khaki shirt came to see me. I think "Scott" was embroidered in red cursive letters above his left pocket. He came and stood by my bed.

"Remember me?" he asked. "I was with you."

There was something in his eyes. He wanted to tell me something, I felt. . . .

"You were next to me?" I hazarded (the man who had crawled in and propped me up inside the car?).

"No, behind you."

And then he was asked to leave.

His image stayed with me. I don't remember his face and can't even tell the color of his eyes. But I remember clearly that they were trying to say something.
They were full of . . . compassionate remorse.

His visit, his eyes, the depth of feeling in them, all kept coming back to my mind. Later, I kept thinking, *There was no space behind me in the car. The fuel tank was on my back. How could he have been behind me?*

And then I realized . . . He was the person in the ambulance—the paramedic, the liver injury! That was the reason for the remorse, the reason he had come to see me.

He wanted to tell me he was sorry.

I caught a glimpse of him again later—or so I thought. Sitting by himself in a chair in the corner of a corridor, his forehead in his palms as I was wheeled from the ICU to my room. They were still monitoring my liver for possible surgery, an injury for which he was beating himself up.

I can still sense his contrition. I wish I could have talked to him, told him it was okay. . . .

Sent: Sunday, October 12, 2014 8:11 PM
Subject: Defining moments

DEFINING MOMENTS. How strange that thoughts can come in such quick succession, thoughts that are actually questions about the most pivotal facts of our relationships, our very being!

Am I still alive?

For a few moments, I did not have an answer to that question. I'm not even sure if I asked myself that. I just wasn't quite sure of my existence.

The brain was first dulled and then sharpened by the shock.

Images, thoughts, questions, all vied with each other to fill my brain, to take precedence.

The heat, the blaring, the oppression—the sky had fallen!

And yet, my brain kept chattering. I had to call my family!

That done, relief washed over me. Now my brain was free to pay heed to its other thoughts.

My son had to be picked up from school. My husband, how far he was, at an overseas office. . . .

Questions were put to me.

"Was there anyone in the car with you?"

My horror at the thought. The wonderment. They couldn't tell? And then a sickening realization: Just how mangled was the rest of the car?

I heard someone call out that I was, "Alive right now."

What if I die?

My mind grappled with the question, and my heart cried out that my son was a little too young to lose his mother. Never had I admitted to myself what a crucial role I had in his life. I was humbled.

They cut the metal near my feet and must have touched them.

"Can you feel anything?" someone asked.

I was not sure. My brain felt numb, yet my thoughts were clear.

They're afraid I've lost the use of my limbs!

With blinding clarity, I answered the question even before I dared put it to myself. Even if I was paralyzed, my husband would never abandon me! He would be by my side come what may. His commitment would be for the better, and also for the worst!

Such a defining moment, such conviction at a time of such stress, such a humbling awakening.

It took these moments, filled with stress, with finality, to recognize in the dark what I couldn't have identified in broad daylight—the truth of our relationships.

WE CLUTCH ON to straws to save ourselves when drowning. Ridiculous, really, since they can hardly be of help. Or so we think.

I did exactly that with regard to my cell phone, tried to clutch onto it. It had been my connection to my family; it felt like a lifeline. It was miraculous that my handbag had been open and the phone had slipped out onto the floor by the passenger seat, and I had been able to use my free left hand and hit the speed dial, all without being able to straighten up and in a crushed mass where I could not even reach the ignition to turn off the car, let alone the blaring radio.

Holding the phone at whatever distance I was able to, I was at least able to get a message to my family.

"I've had an accident . . . I'm bleeding. . . ."

That's all I could manage. And to me, that said it all! I was in a bad situation.

It was this straw that saved me, lessening my mental anguish as I connected with family, however brief or one-sided it might have been—as I was drowning.

I clutched onto it again as I was put into the ambulance more than an hour and a half later.

"My phone!"

"Your phone and purse are with you."

The relief!

Laughable really, but never had communication seemed so imperative. My son had to be picked up from school. . . .

MY SON HAD been picked up. I received the message. The relief!

And then . . . *Our puppy must be lonely . . . The cleaning ladies must have left . . . I have tutoring at four . . . The mother needs to be informed that I can't make it . . . Reschedule the class. . . .*

Thoughts and lists . . . To do, to ensure that all ends were tied up. For that evening. . . .

And then I was told I couldn't go home!

The looks on their faces when I protested!

I wanted to go home!

But there was no choice. Decisions were no longer mine.

The carpet cleaners were coming the next morning. Key under the mat and a check. And our dog's appointment at the groomer's. . . .

I was in control—or wanted to be. Life had to go on, exactly as if nothing had happened!

My brain was clear despite the morphine. That was just a complication. It made me want to throw up.

I wanted to take back the reins.

PAIN—MY PHYSICAL injuries were inconsequential considering the fact the accident had been quite horrific in its actual impact and physical appearance.

The CHP (California Highway Patrol) chief made a statement, saying I was "very, very lucky" to have miraculously survived when the car had been "accordioned". I was in the news!

My right hip suffered the worst damage—not so much from the impact (I think) as from being crushed in and bent over to my right side and being in one position for more than an hour and a half. That's it!

My right hand had been resting on the passenger seat. Glass pieces were already in it and had only dug in deeper and increased in number as I was pulled out.

The ceiling and/or the left door was pressing down on my left shoulder, and my body was up against the steering wheel. My fuel tank was on my back, and the truck's engine was still running above my head. Hot oil from the truck poured down onto my left shoulder. My light cashmere jacket was soaked through with the warm, thick liquid. Seeing the blood falling on my right, which came from my forehead, I could only imagine that what I felt on my left was blood as well. I couldn't turn to check, because I couldn't turn at all!

The person who peered in first—the driver of the car that had been behind the truck, who had stepped out to inspect the accident and help me—asked me a question that was put to me repeatedly.

"Was there anyone else in the car?"

My answer might have simply been, "no." Perhaps it was, but the feeling of devastation and finality that surged up at the very thought chokes my throat even as I write this. . . .

And then, the more prosaic stuff. Where could I feel my injuries? The blood was obvious. As I told him that I was bleeding on my left side as well, he reached in and felt it and then withdrew his hand and said I had oil pouring down on me from the truck engine above, oil that poured continuously and became a sort of puddle on my arm, eating away at the flesh as if it were corroding it.

Glass was all around, it seemed, and once they had lifted the truck with the crane, they proceeded to break my windshield. It was raining glass. The man next to me, trying his best to hold me up, held his orange security vest in front of my face, but the glass still came.

There was glass in my hair, in my scalp, and burrowed into the palm of my right hand. Most of it was removed at the hospital, but some shards, which I could feel and the doctors could actually hear against their instruments when poking into the wounds and see on the X-rays, were unreachable.

Finally, it was pronounced that they would come out by themselves. It was unsettling, to say the least, to have glass inside me!

The horror of glass stayed with me for a while. I recall looking for glass pieces next to me, on the carpet, everywhere! I was always reacting to glass. An empty glass placed innocently next to me would make me snap. My reactions were sudden, sharp, and abrasive, I am sure.

My hip hurt terribly. Movement was impossible at first, difficult later.

When my husband first saw me, he broke down and began crying. "What have they done to you?"

When he helped me take a shower, he let a sound escape his lips. It was the sound of horror. When I looked at the part of me that I could see in the mirror, I had all kinds of colors on me, bruises

The sight of my face shocked me—*grotesque* is the only word that comes to mind.

My head was swollen beyond belief, and my face was bruised and swollen. I had a long, deep split, open flesh cut in the center of my forehead where it had hit the steering wheel, stitched up now with black thread

My body took some time to heal, and I pushed on doggedly in my efforts to regain mobility. My hip had physical therapy and recommendations for surgery—repeatedly—but no one could guarantee that it might not lead to further complications and distress.

I still hurt 24/7. I do yoga regularly and walk as well.

I wear heels higher than the ones I wore before the accident. They make me hurt, not right then but later, for a couple of days afterwards, as if metal rods have been thrust into the ends of my hips.

But it makes me feel good! I don't want to feel limited in any way!

THAT'S ABOUT the gist of it.

I could feel the physical pain acutely, deal with the limitations it imposed and the disfigurement that came with it.

All of those were, for the most part, concrete.

My hands were black, stained around the nails because of the engine oil pouring down on me. A manicure almost took care of that aspect.

The ugly, black stitches in the middle of my forehead were replaced by white tape. That was progress.

The swelling subsided, and the bruises faded away much as the sun sets on a brilliant day.

I went from needing a kind of casing that seemed to pump my calves repeatedly (the nurse said it was to keep the blood flowing and challenged me to get up and try to walk instead when I complained about the discomfort they caused) to walking by myself.

The burns on my arm, from the hot engine oil, pronounced as "third degree" healed, and regular applications of ointments ensured that the scars faded.

Even my liver, an organ buried deep within the body, could be seen on a screen, and the extent of its injury (pronounced as "second degree") assessed and observed for possible surgery.

What could not be seen on the surface or on a screen and could not be addressed were the injuries within me. Nobody knew what they were and to what degree they were, not even me.

To my mind, I just needed to get back on my feet, get a manicure, get the remaining glass shards out of my palm, let myself heal for a couple of days. Then I would be fighting fit again.

I was more concerned about possibly gaining weight since I wasn't working out.

Whether it was a refusal to accept the gravity of my experience or a genuine lack of understanding of the same, there was no hint of any internal struggle.

This omission or oversight could very well have allowed the wounds to fester.

IT ALL BEGAN with the first accident, about a year prior to the second one, when a careless driver cut me off.

I was apologizing to the firefighters and paramedics, telling the police that I had left the oven on at home since I had expected to be back in a few minutes and repeating that it was necessary and urgent. They kept reassuring me it was okay.

I asked them to call my husband and also to get a message to my son, who was waiting to be picked up from his guitar class.

I wanted to go back to work the next day despite a shoulder injury and burn on my right side. I needed to be back in control and routine, as if to wipe the slate clean.

But my fears were not being wiped away. I was reacting to sudden changes on the road. Nervous and jumpy. Expecting people to run a stop sign or cross my path. The fears were very real!

But I shrugged off offers for medical leave and such.

When I was sent home from work categorically one morning on the decision of the HR department, saying my shoulder injury was a liability, I went straight to the hospital and met with the doctor to request a clearance that proved my injury was manageable and that I could still work. Not that breaks and weekends weren't my favorite times. I just didn't want to be out of routine.

My need for structure and discipline and my commitment to my work came before everything but my family. I also had a need to stay in control of myself. Moving away from feeling grounded bothered me immensely.

Then came the last day of school before the winter break. Christmas celebrations were in the air with class parties scheduled that day, getting ready to administer the math test first thing in the morning when all was dealt with precisely—before we called it quits on the work part and proceeded to have a fun day.

But right then I was told I had been made redundant, that my class was to be combined with that of the teacher who taught the other section, the teacher whom I was still mentoring.

In a split second, I had gone from being the highest-paid teacher across the multiple branches in multiple states of the prestigious private school system in which I had worked for nine years, where I had trained teachers and mentored them on a regular basis, where the owner, the corporate office, the administrators, and the parents held me in high regard, and where I was treated with great respect and pointed out as a role model, whether it be in teaching or classroom management or even appearance, to being made redundant—unceremoniously and with no notice.

"When do you want me to leave?" was my only question.

Since it was the end of the day and I had the winter break to clear out my stuff, I went back and administered the math test, went out during my break to buy muffins for the staff lounge—on which I put a "Thank you" note to all, and proceeded to bid a courteous farewell. I even hugged the principal and said, "Thank you" in the packed auditorium in plain sight of students and teachers—the same principal who had given me my marching orders that very morning.

The tears of the students, the teachers, and the parents who flocked around—the news had spread like wildfire—actually empowered me. They kept me going and did not allow me to weaken.

I had called my husband to tell him I had been laid off. He gave me his complete support. He told me not to worry and told me not to sign anything.

During and after the winter break, parents and students kept reaching out to me. There was a "movement" of sorts. A petition was put together, the corporate headquarters approached, and meetings requested. Parents of ex-students from years past had joined in or had been roped in. It was heartwarming to know they cared so much, that I still had value in their eyes.

It was nice, in a way, to get these pieces of news, but I actually wanted to be left alone.

Yes, I would come back to complete the school year for my current students. I agreed to return if asked and even offered to work free of charge. I owed it to my students!

But the school did not want me.

I did not take up another job as an educator, a profession that I had chosen as a child and that I had taken up part-time even while still a student.

I decided to change careers altogether. I was taking online classes, considering new prospects, new plans were underway. . . .

Within a year, I found myself crushed by a truck and lying stark naked—on the freeway.

NOT FEELING LIKE taking care of myself.

Not dressing up.

Not wanting to meet anyone.

Getting stressed at the prospect of having to go out just for a dinner with extended family.

Stressing about EVERYTHING!

Silence worked for me, and being solitary in the bedroom with the door shut was comforting.

Neither did I want the TV nor music.

I had always been an avid music listener. When I had the second accident, I had just begun to enjoy songs on the car radio again—for the first time since the previous accident! I had actually thought of that and just remarked on it to myself. . . .

And then . . . the NOISE!

The loud music, the blaring horns, the crashing, the crushing, the breaking. . . .

And I couldn't even reach the ignition to turn off the engine!

So the car engine was running next to my head, the truck engine was running on top of my head . . . and the RADIO!

Sound became noise for me, a noise that was and often still is continuous in my head.

There is no escape.

Disharmony among people, unkindness, all seem like screaming inside my brain.

I long for pleasantness. Yet, I realize I don't sound pleasant, though the intention is actually and genuinely to be so. I sound abrasive and short and asocial and come across as the same, judging by the reactions.

I react when there is a sudden sound, especially if it is behind me.

My nerves feel frayed, and my reactions are immediate.

Often, the reaction is not obvious. If it's not something loud and sudden, I don't necessarily respond. Instead, I become edgy and short and withdrawn. I stop participating, and I'm certain my body language and expression tell the tale better than if I were to scream it out!

But, I am not in control.

I don't take the prescription painkillers. I feel inadequate. They made me edgier, just the thought of taking such tablets, as if I'm not in control.

They felt like such a burden!

I felt and feel incapable of taking charge and being in charge of myself.

I maintained a healthy weight, kept myself looking slim, but I couldn't be bothered to do more than be clean. The same person whom almost no one saw without eye makeup, at the very least, in the past was always trying to hide behind a visor.

HIDING . . . FROM PEOPLE . . . from myself . . . my feelings . . . fears . . . limitations.

Not wanting to accept my shortcomings, not wanting to believe I was not in control.

Not wanting to be accessible or have others recognize who I was or who I had been.

I had found myself at the bottom of a dark, moist, newly dug pit.

I found its deep darkness a relief. It saved me from the sympathy and understanding of innumerable friends and acquaintances.

It felt safe.

I WAS A tangled mass inside, feeling confused and helpless and without a clue as to what to do or where to begin.

Whether I presented a rather remote and disinterested front or a brittle armor, I have no way of knowing.

What I do know is that I tried to push people away, people who made my world and were my world.

I carried darkness and gloom inside of me. It shrouded everything around me. I could not lift it, so the answer was to isolate myself.

I would stay in the bedroom, sitting up in bed, reading a few words here and there, but mostly just vacant.

There weren't any terrifying images in my mind, haunting me. If there were, I could have justified myself. I would have had a problem that would justify the endless hours. Somebody could have helped me. . . .

But my state of mind was a vast, unending wasteland. The problem was its emptiness.

Sent: Wednesday, October 1, 2014 5:01 AM
Subject: When two worlds

WHEN TWO WORLDS drift apart. . . .

There was such a gap. Not a rift. No shouting or flinging matches. Nothing unpleasant.

I was simply not there—not for my husband and not for my son.

I had alienated myself. I was not worthy, able, capable.

I wanted to be left alone.

Deep inside, I knew I was loved dearly, cherished. I had already received affirmations of my worth and my place.

Yet, it was as if my defense mechanism gave me a prickly exterior.

I think I was short and abrupt with my husband more than with my son.

The main thing is, I was simply there. . . .

I didn't even interact enough to have altercations, arguments, about anything.

Sent: Friday, October 10, 2014 5:06 PM

Subject: My questionnaire at

MY QUESTIONNAIRE AT the psychologist's office would always tally up to the number of points that made the patient feel inclined towards . . . suicide.

It was a generic printed form!

"Do you feel happy, want to talk to people, take an interest in others? How much? Please circle on a 1-5 scale."

"Have you had any thoughts of committing suicide?"

I couldn't blame them for asking. A 15 or above on the form meant "suicidal."

Of course not! Didn't they know I was struggling to stay alive? To live!

Because I had a husband and son who would be devastated to lose me! Because there could be no pain worse than what I could inflict upon them—for their lifetimes—than the one a selfish and thoughtless attempt to end my life would bring.

I could think clearly. I was not losing my mental balance. I was just not able to clear the tangle and . . . be happy.

Didn't these mental health professionals who had been talking to me, taking notes, listening, understand this?

But they were following the protocol, the format, the numbers on the form.

They were trying to put me into a category, to gauge my reactions, to put meaning into my actions and to interpret my body language and words.

That was their job. They were educated, trained, and experienced.

But I was not a Type A, B, or Z!

My personality was unique, my fears were unique, my limitations were unique, my experiences were unique . . . my family support was unique! How could so many unique factors possibly result in a condition that was not unique, that could be categorized, boxed, numbered, and labeled?

I understood the task with which they were faced, but I didn't know how I could help!

What I did know was they weren't helping me, despite trying desperately. . . .

Sent: Saturday, September 27, 2014 12:23 PM
Subject: Quantifiable injuries are

QUANTIFIABLE INJURIES ARE easier to diagnose, to categorize, to create a plan for and remedy.

They are scalable.

But when the symptoms are so varied and often contradictory, and the ailing person's cooperation is of utmost importance in both the diagnosis and the treatment, and the brain is not party to the process, it creates further stress.

The main part of the problem might be its actual acceptance and recognition. And even if they're there, we are already part of a family and a society with a need to play all of our roles, as expected.

Our training does not allow us to scream and shout and wail in pain.

A stoic acceptance is very well on the surface, but down below there might be an actual conflict in the mind.

Am I really suffering that much? Am I justified? It was just a crash, and look how well I'm doing.

In our effort to be positive and practical, we shortchange ourselves. We feel genuinely confused regarding what our reactions should be.

We put standards and embargoes on ourselves.

A LACK OF structure and complete freedom to do as I wished.

Even within the parameters of family and community, I had no accountability.

The absence of pressure was a relief. But then I found myself building up my own structures, putting down rules for myself, goals, and expectations, all of which gave me something for which to strive, something for which I would feel answerable.

Whether it was fasting or abstaining from certain kinds of food for days on end, I found some concrete, tangible guidelines and goals that I set for myself and then derived comfort and strength from adhering to and achieving.

Of course, my husband and son supported me. They supported everything I did, through action and through tacit agreement. Perhaps they hoped I would be able to find firm ground beneath my feet.

I was on shifting sands.

My biggest fear? That they would become sinking ones.

I was clutching on to rules and a routine, trying to make it organize my days, with the hope that it would clear out the fog, organize my mind.

THE FEAR THAT life is getting beyond us, that it's not just a matter of when we decide to get up and get out of bed that the day will begin.

The inability to get a grasp on what seems like such a concrete when all is well—yet such an intangible abstract when it slips away. . . .

Thank heaven for family and for the role we are assigned in it, for our community and its expectations, and for society and its norms.

They keep us grounded, keeping a check on us and setting standards to which we have to live up.

If I didn't feel like getting dressed and being well turned out, I needed an excuse to still be considered "presentable."

My justification for being shrouded in a zippered jacket and visor to top my exercise clothes and sneakers was simply that I was in the process of going for a workout. My outfit was a license! A license to hide my face and make no effort to dress up.

If I was going to drop my son at school, I made the extra "camouflage" effort of wearing sunglasses and lip gloss, extras that served as a temporary quick fix.

Using excuses and trying to pass muster were results of what I felt compelled to do to "work the system," a pressing internal need to comply with the external pressure—that is, people. . . .

While I could argue that I had undergone a unique set of experiences and was

an individual who needed both space and time to find myself again and to come to terms with life and that I was living in a vacuum, I knew I was not in the clear.

Even in my dark despair, I had enough awareness and felt enough pressure to look for and find a niche that was comfortable and acceptable.

Norms to measure up to and standards to relearn to live by; rules and expectations helped to form the scaffolding. . . .

Sent: Friday, September 26, 2014 8:08 PM
Subject: My moods and

MY MOODS AND my inability to "bounce back" were often put down to my actual physical pain, for which there was no relief, since I would not take the prescription painkillers—Vicodin being one of them.

Next, I was referred to pain management clinics—acupuncture and another treatment that recorded my pulse as I watched different scenes on a computer, a kind of guided program over a schedule of 4 weeks or so.

I went for only one and insisted that I could not make it for the others.

Pain doctor, psychologist, pain psychologist—I had them all, and then the orthopedic surgeons. Each one had a plan, and each was genuinely trying to help.

An MRI was required to look into my hip. I couldn't handle the enclosed space, so I was prescribed Valium and a variety of other relaxants. No luck!

My fear was so great that I would still move, even in the largest MRI machine.

So, the orthopedic surgeons had to guess what they should do to help my hip. Replace it? But the success rate was not 100 percent. And what about the other hip after a few years?

Questions and speculation and shooting in the dark and asking me about my wishes.

All I wanted was to be left alone, to live life again! No one could help me with that.

Appointments and procedures were weighing me down. I would go to them with the hope of getting back. But they were taking over my life, and the sympathetic actions and reactions did not allow me to forget that I was . . . lacking.

I think it might have been my desire to let my husband and son have ME back again, to lift their burden of worrying about how I was feeling, what would please me, that made me want to make an effort.

I realized I was not creating happiness. I was taking away from it all the time, playing the victim, and I was not a victim!

Things beyond my control had happened, and I could not regain control— that's what bothered me. . . .

MY HEART WAS not in it. Physical therapy felt like a drag, and I shrugged off the gentle exercises I was advised to do.

I was going through the motions: make the appointment, show up, cooperate, and schedule the next appointment before leaving with a pleasant, "Thank you."

The answer to my problems of pain and limited mobility was not in any department in a hospital.

I had it!

My confidence and faith in the "all will be well" philosophy remained firm.

I was in control!

It was as weeks became months, and I sank into a dark gloom without having the slightest clue that I was headed that way, that my mind first accepted the facts—it was not that simple. Things do not fix themselves.

Time was not the only ingredient I required to heal. It required more than an ability to suffer through. Being a passive bystander wasn't going to help. I was and would continue to be in the deep, dark dungeons.

I knew I had to call the shots.

What I had thought would be productive and would get me on my feet was proving to be counter-productive. I was a patient. I had packaged and labeled

myself as one.

I was the one who had to rip off that label, tear off the packaging, shake myself out, and take charge.

The day came when I stopped all appointments. That was it!

I began to go to yoga regularly, walked my puppy an extra round, and tried to get away from being a patient.

Sent: Friday, October 10, 2014 9:05 PM
Subject: I had been

I HAD BEEN a story book teenager.

Glasses and braces. The glasses had soon become a thing of the past, because I didn't need them anymore. But the braces were simply ineffective.

I had slightly protruding teeth, as I liked to describe them. "Buck teeth" sounded rather drastic.

I also had a very well kept head of hair—short, nicely-styled, and very neat. It was given to turning grey of late, but I kept its natural color—with much pride. I used the greying as synonymous with experience when thundering at my students—very effectively!

All in all, I was content with my appearance and took pride in it, shortcomings and all.

But that was when I had confidence, an identity, was held in high regard by the outside world.

After the accidents and the layoff, I was a non-entity! Even my Google account went by that name, a fact that was brought to my attention by an incredulous friend. So taken aback was she that she asked if I had simply not chosen a name and Google had called me that. I couldn't answer, because I didn't remember.

A non-entity is certainly what I felt like, though.

I wanted to get back in the harness. I had already managed to get back into

the driver's seat. Now all that remained was to look great.

What exactly I was trying to achieve, I don't know, but I set about trying to fix everything I could.

Perhaps I felt that, in the process of making the best of my outward appearance, I would be able to heal and fix what was falling short on the inside.

I could see the surprise on my husband and son's faces. "Invisible" braces, changed hairdressers, experimenting with new hair products and hairstyles. . . .

I, who had had the same hairdresser and hairstyle for the last 12 years, was going through . . . a crisis?

I could control my looks. In the course of doing so, I was trying to control my internal turmoil, to regain control of myself.

I had always been a careful dresser, well turned out, carefully, if subtly, made up. Now, that wasn't enough. I needed to come back better than before—to have that "wow" healing moment.

I did achieve the external changes—finally, all to my advantage!

The inner self was still a challenge. . . .

I FOUND MYSELF looking for that moment when things would change suddenly, thinking, it was just around the bend.

But there was no eureka moment, no key to the future.

What was an endless tunnel initially, one that I had been living through without any resistance at all, I now wished would come to an end.

I had no escape from myself and my inability to get back to myself.

Getting away, writing, being by myself, finding myself—rather wishful thinking.

All the pieces I could have conceived as creating an environment for . . . a chrysalis.

I had the formula, and my husband and son were desperate to see me happy.

I did what I had never done in my life. In the sheltered and deeply caring environment that my family had always provided for me, I had never even conceived of the idea of driving long distances, going away by myself to a resort, to spend 4 days in a villa, trying to write.

Write what? My experiences as a teacher was an idea I thought I would work on. . . .

I was serious—seriously desperate to grab something that was out of reach, an identity and mental peace.

I already knew I could grit my teeth against a biting wind and plod on, but that was my physical strength and mental courage!

That peace and calm that I needed, that sense of security and the confidence that I, myself, could be in control of my own mood, my own mental state, was still a pipe dream.

No amount of sitting with a cup of tea watching the sun rise or set or having the fire burning in the fireplace and casting a glow around the room and creating an atmosphere of warmth and comfort . . . nothing helped.

I had packed healthy snacks and had every intention of being disciplined and churning out page after page and story after story that would be revealing and inspiring and that would help teachers and parents catch discerning glimpses of a variety of students' personalities.

Oh, I did write! I even emailed some of it back to my husband, who responded with strong praise and great encouragement, but my heart was not in it. My mind couldn't find peace.

There was a clamoring in my brain that had nothing to do with where I was— environment or beauty or quiet, nothing.

I spent my days aimlessly and ordered in pizza and soda—menu items that I generally avoided as a calorie-conscious person.

I had no self-control. Now I was trying to find comfort in food!

I had been seen off by the most protective and loving husband and son one could conceive of, who had faith in me and wanted to support my desire to get away and achieve something—unquestioningly.

But I had let them down. I had, of course, let myself down as well.

I came back home four days later. I can't even say I was defeated, because for that I would have to have been worse off than before. I had simply used up another chance.

That's all.

HOW EASY IT should have been to lead the life of a lady of leisure.

I felt like a failure.

Actually, I wasn't really able to put a label on what I thought I was. I didn't give it logical thought.

I existed. I hardly slept. I hurt physically, but the turmoil was inside my brain. Like breakers against unyielding cliffs.

A constant surging and upheaval and yet, a stillness that seemed fragile.

I felt fragile and was treated as though I was.

The irony?

The more caring that was shown to me, the heavier the burden became.

I wanted to snap out of it.

All the ingredients of a perfect home were right there.

A caring husband who was literally at my beck and call.

A darling son whose days revolved around me.

And our little puppy, who made no bones about showing his unwavering adoration.

Everything had story book-like perfection, and yet I was falling short by far. When I should have been happy, I felt thrust upon, irritable, and short.

Guilt bore down on me.

I RECALL SHARING my guilt about how nice my husband and son were, how much they had to put up with, what they forewent for my sake, everything.

I had apologized repeatedly to the firefighters, the paramedics, everybody.

It came naturally.

I remember one or a couple of them actually laughingly commenting on the same during the first accident.

One of the psychologists actually asked me if feeling guilty was a "safe place" for me to be.

That stuck in my mind. It probably was. . . .

CRABBY, CRUSTY, SHORT, and downright rude!

That's what I was when I was referred to yet another psychologist. The lawyer needed depositions from outside, unbiased professionals.

I had no intention of telling her my story. I had already repeated it over and over again to a variety of caregivers. I was "sick" of telling it.

That is how I started the conversation.

I didn't intend for there to be a conversation. I was there simply because I was supposed to be—it was the next step. I had to go to her "at least once," and I did exactly that. I went—just once. I even told her that!

I can't describe her, because I don't remember what she looked like. But I do recall a patient understanding in her eyes. I knew I was being obnoxious—and she was calm, waiting. . . .

A word here and a suggestion there. She did manage to extract one aspect of my anguish—guilt!

I felt guilty! Guilty that I was such a bother, a burden, an impediment! For the people who cared so much for me, who suffered through it all without any end in sight, without giving any indication of what they might actually be suffering themselves.

My husband and son, who were overjoyed—pathetically so—every time I displayed the least bit of happiness.

It was bearing down on me. I felt guilty.

And my pain for the truck driver, my sympathy for what he must be going through. Sleepless nights, perhaps?

And what about the paramedic who had made the mistake of putting a capillary tube into my liver when he intended something else, causing a second degree injury to my liver and one more reason for monitoring and possible surgery?

These were some of the haunting images—my husband and son's eyes, full of love and pain for me. The thought of the burden of guilt on the driver and the paramedic. . . .

All the emotions were jumbled up. Churning constantly in my brain. Noise, the sheer weight, bearing down on me.

I shared some of these images with the psychologist. She managed to get them out of me despite my firm resolve to be uncooperative.

And then she spoke. Initially, I didn't listen. I didn't mean to seek help. I didn't need it, didn't want it!

But some process of osmosis must certainly have taken place. The parched mind absorbed some wisdom, involuntarily.

I heard her refer to the Bhagavad Gita. She was not using its philosophy but rather a situation from the battle that forms its backdrop.

Her point was I was caught in a trap, a concentric battle formation, the Chakravyuh, that I had entered voluntarily but didn't know how to get out of.

A hamster on a wheel was her second analogy. I didn't know how to jump off and kept spinning.

She gave me specific advice: Separate your emotions. Rejoice in the love showered upon you. Take it as your right!

And, more importantly and more urgently, stir up anger inside yourself.

She wanted me to find release through directing anger against the truck driver who had been careless and created such havoc in so many lives and against the paramedic who had been clumsy.

"Find an opening . . . absolve yourself . . . get rid of your guilt. Be angry!"

But, in my book, the two were not at fault. They had made genuine mistakes. I knew the second was contrite, and I was sure the first must be!

My own philosophy of judging by intention was proving to be a roadblock. It did not allow me to believe or act in a manner contrary to it.

I had been hurt, and I was being showered with kindness. I wanted to be kind myself to those who must surely be hurting!

I remained the hamster on the wheel . . . in the Chakravyuh.

There was no release for me.

I COULD SEE the pride in my son's eyes when I dressed up and took care of my appearance.

It was heartrending to see just how much I could affect how he felt simply by virtue of how I looked.

And then, the anxious looks to see how I was responding to the TV show. I wanted to look animated, because he had made the choice of show for me.

But the trouble is, his perception and intuition make him a person who couldn't be fooled.

Try as I might, "nothing" carried no weight when provided as the answer to the question, "What's wrong?"

Eyes might allow us to see things, literally, but they give those who love us a clear glimpse of how we really are.

How does one camouflage their emptiness?

The starkness that lies deep within the heart is reflected, unfairly magnified, in our eyes.

They belie the words and the pinned on smile.

HOW DOES ONE gauge the extent of others' anguish? The fears that gripped them, the sacrifices they made?

I doubt they could even recall each decision they made and each pleasure they had to forgo.

Life had taken on a different hue!

What would be termed a sacrifice in everyday terms was probably simply a reasonable and matter-of-fact decision in the days of testing.

And a test it certainly was!

My husband's commitment to an upwardly mobile career path couldn't stand it. He changed roles to cut out all foreign travel, time away from home.

My son's priorities made him give up a team sport he had pursued through the previous five years on cold, foggy evenings with piles of homework waiting to be completed and hot summer months when he could have been hanging out with friends. A sport at which he excelled and that would have helped him on college applications, but the pursuit of which would have meant lonely evenings for me while my husband drove him to the games and practices after school.

He was dropped out of from the team on which he had been a star.

Just a couple of examples that have come to light recently and inadvertently.

The first in the course of a conversation with one of my husband's former colleagues and the latter during the college application process.

How many more such truths will I uncover? How many more reasons will I have to feel grateful yet guilty?

Yes, guilt is what I feel. Its absence would make me feel selfish and ungrateful.

I could give advice on how each person is doing and contributing what he chooses, so the question of guilt should not arise. One must simply appreciate and bask in the love.

But I, myself, am not there . . . not yet!

FEAR CAN BE so real.

The cowering and cringing that comes from knowing you're facing danger.

But when danger comes in a split second, you don't have the luxury of reacting—it's happened already!

You're already in a vortex and spinning even before you know it.

So, is it that the reactions come later? As an aftermath, and seem ridiculous, because the danger already happened?

Does the brain still need the time it could not use for anticipation to reenact the horror and let the fear build and bury itself inside so that, in the future, any semblance of the incident can trigger off a series of reactions?

It may be color or speed or sound—anything at all that can be remotely associated with any part of the trauma—and I am reliving it. And the reaction is exponentially worse.

I find myself cowering if an explosion happens on TV, shaking with tears streaming down my cheeks if glass shatters, or feeling desperate and crushed in if I see a scene with people stuck in an elevator.

I'm not sure how much of my staying away from TV has to do with what I fear I might react to.

Surround sound does not help.

Sounds of cars speeding come from behind me!

Nothing could be more graphic.

Driving on a crowded freeway once, something I almost never do now, I found my hands lifeless and clammy as they tried to grip the steering wheel. It felt like my foot was only the arch of it. The arch could not meet the pedal—and it was dripping sweat!

The choice was between driving to the shoulder and calling my family or 911 or continuing with cars all around me, moving sluggishly, menacing and torturous.

Moving to the shoulder meant changing lanes, and I didn't have the courage to do that. So I let the crowd carry me along. . . .

SOCIALIZING—ACCEPTING INVITATIONS and issuing them—can be an intimidating task.

I found that the moment I heard that I was invited, I was assailed with doubt and apprehension.

I was panic-stricken, as if I was in danger of being exposed.

Couldn't I just continue to exist?

I wanted people to realize that I cared a lot and that "it wasn't them, it was me." We would just suspend all interaction 'til, well, I didn't know when.

Friends, I didn't even have conversations with . . .

Extended family, I tried to keep social interaction restricted to actual important celebrations with . . .

Invitations that were just for our family, I felt compelled to bow out of.

The hope that our reluctance would be understood and not be hurtful was fervent.

I did try to be open and honest—there were no lies—but then there was no socially savvy excuse either. Just a bald statement about not really being up to it.

It was unfair to my husband and son, I realize.

I had cut them off from the rest of the world. I was self-centered and completely self-absorbed.

I'm not sure how I would have done had either of them professed the wish to go, to accept invitations, to stop living in a bubble.

I won't know, because they didn't contradict anything I said. I was passive and seemingly retiring, but in reality, I had the reins firmly in my hands and was guiding us in the direction that felt most comfortable to me.

I derived power from their ready acceptance of all I displayed the slightest sign of leaning toward.

I was being spoiled, and I was taking undue advantage of it.

In my silence and my withdrawal, I was able to achieve what I wouldn't have with a display of tantrums.

Was I being "passive aggressive"? That is the popular term.

Perhaps I was!

But, I didn't do it deliberately—I can say that with certainty.

I understand what I did, and I forgive myself as well. My intention was not to blame, but I am to be blamed for its results.

I deprived two people who wanted to give me the world from being part of the world for several years.

Simply because I was licking my wounds.

WATCHING THE NEWS, which, more often than not, is full of gory details of unfortunate events, can be a trying experience.

My reactions are intense—though seldom apparent. The irony is that even I can't understand my reactions, let alone gauge or describe them.

And, what you can't even detect and decipher clearly you can't address or manage to any degree of effectiveness.

The sound of shattering or metal clanging or even the heat that was generated in the crash is a living memory that is always waiting to surface. It just needs a hint of a spark.

One of the psychologists tried to make me understand why I felt things as strongly as I did—more so than I had before. She said my shell had been cracked open, that I felt things stronger than most others who had not gone through similar situations.

Yes, I might have become more sensitive, and what is exciting drama on the screen for others may leave me anxious, distraught, and a bundle of nerves, and it is all very real.

What bothers me is that my son seems to have trained himself to catch all of these triggers. He is so tuned in to what I am witnessing and how I am reacting that more often than not he will act as a defense or distraction even before I have had a chance to respond to the stimuli.

It is touching and saddening. I feel that I have taken away the chances he

would have had of enjoying a good action-packed drama on screen simply by virtue of me having been in a couple of car crashes—that I survived literally unscathed. Well, on the surface, at least. . . .

I berated myself for having scarred my son in this manner. It was one more burden of guilt to bear.

It was such a relief when, one day, I found him watching *Tokyo Drift*—a car racing movie!

That he turned off the TV just as I came through the door and did not let me see the screen or hear the sound was telling of the fact that he wanted to save me any stress.

A large part of my stress was actually relieved—because he was being a teenager!

REAL ANGER CAME during my deposition for the lawsuit. The insurance company's lawyer was supercilious and condescending, and the first thing out of her mouth was that she was sure my lawyer must have prepared me well.

When I began to recount the accident, as I was asked to do, I broke down. I was actually shaking and crying like never before, sobs wracking my shoulders. I had to go out of the room and calm down before I could continue.

The questions were an invasion and callous to the extreme.
They asked how many times my head had hit the steering wheel. My response of "several" was insufficient.

I tried counting. Well, probably, once when the truck hit me initially, then five times as I was pushed into five cars ahead of me, and then once more as the truck driver swerved and then pushed my car into the railing on the side. What does that make it, seven?

That was when anger set in. I was upset and furious, such a blatant display of insensitivity!

My world was upside down and inside out, and I needed . . . a reprieve? An apology? An acceptance and admission of all the agony and distress the accident had caused me?

I was sorry for the driver, for what he must be suffering. . . .

He had been absolved.

So it was the trucking and insurance companies—firms rather than individuals—that I felt justified in holding responsible. I was nothing but a case number for the lawyers and the insurance company representatives. It was as though their acceptance and apology would help me heal. . . .

A TIME OF acceptance, of facing reality, of knowing that I was not in complete control.

It was perhaps the moment I realized that my memory had taken a beating. That a faculty, an inherent part of my being, of my existence, was missing— perhaps in parts but missing nonetheless!

I didn't even know what I didn't know anymore. That was the greatest disabler!

I felt crippled, something I had not felt even when I was immobile.

The inability to walk had been tangible. Yes, it had been temporary. Perhaps more so, simply because I had pushed myself. Pain had been my resisting force, extreme and almost unbearable. But then, extreme and unbearable are still measurable and scalable!

Here was an abstract—memory. How do you recall what you just can't recall, what is simply a black void?

It was this . . . affliction, if that is what it should be called, that was my red flag. But I wasn't going to let it be my Waterloo.

My appointments became a quest, and my doctors' visits purposeful. I had a mission. I had to heal myself or find a way to overcome my shortcoming.

Searches on memory loss brought web results that pointed largely to only one solution—memorization!

Such a prosaic answer to what was proving to be a terrifying reality.

The shame, the loss of confidence, the feeling of being tongue-tied—all because I didn't know what to say or, more importantly, what not to say to give myself away.

Humbled because I had my two men who understood, accepted, and stood staunchly by my side.

And our dear little dog, who couldn't care less!

Sent: Thursday, October 9, 2014 4:27 PM
Subject: The switch was

THE SWITCH WAS from being a passive patient to being a participant. Seeking the answers, trying to clear the fog in my brain to find—I didn't even know what it was that was so elusive.

What I did know was that I reacted strongly but never really felt things….

Remembered so much . . . but so often . . . just couldn't recall.

I was behind a thick glass wall—shatterproof and insulating. Trying to cooperate to find the key that would let me back into the world. . . .

The solution didn't come all at once—there was no eureka moment.

"SHE TRIES TO hide. To make herself invisible. Sitting in a corner of a sofa. As if she is apologizing for being there."

That is what my lawyer told me my brother had said about my behavior at family gatherings.

How perceptive! How well he understood how I felt!
But I recoiled at the thought of having been caught out.

I had built walls around myself. Kept interaction to a minimum and communication well managed. What part of me had been a traitor?

The fear of being "found out" was oppressive. My self was struggling to bring my mind and body under control, but to present a facade that belies the reality is easier said than done.

Those who loved me . . . saw.

I HAD BECOME a recluse and, a stage later, progressed to being reclusive instead.

I wasn't ready to be part of the world again.

But I wanted the world to know that all was well with me. On the "Facebook of it."

A few well-chosen photographs, a couple of posts, and a long list of friends. I was glad to be "connected" and relieved that I didn't need to actually . . . connect.

That was as far as I got with reviving socializing. If a person was on my friends list, I had fulfilled all obligations that I had to myself with regard to maintaining relationships.

A "like" was an entire conversation, one in which I had conveyed my caring and appreciation for the person

Private messaging threw me off—it got into my personal space. I feared questions. Which weakness would I reveal?

My typical response was brief and ended with a summation, such as, "Take care."

It said that I cared and wished the person well but was not "there."

Being there felt vulnerable, exposed. . . .

I FOUND WRITTEN communication the easiest.

I, who typed with one finger and, more often than not, found myself searching for a letter that I felt sure existed on the keyboard but which proved elusive just when I needed it most, for whom emailing was a task and picking up the phone instead had hitherto been a much more viable choice.

Because I could hide behind the written word.

"Putting it in writing" is likened to exposing oneself and being pinned down. For me, it was doing the exact opposite.

My words were chosen, the tone even, the inflection calm, and the subtle nuances well within my control.

Nobody could find a chink in my armor.

They couldn't hear the real voice, the voice that lacked the confidence and control the writing suggested.

MY PRIMARY HEALTHCARE physician shared my information, my situation, my lawyer's request for a deposition, and her reservations with regard to being involved—everything!—with a mutual acquaintance, who contacted me promptly and took me to task in no uncertain terms.

I found myself apologizing—and agreeing.

Of course my doctor was justified in her reluctance. The request was ridiculous, and surely my accident and my situation and treatment did not justify such a request from my lawyer. Accidents are commonplace. There are always plenty of patients to be seen from those, and asking my doctor for a deposition was certainly not required! I agreed to it all.

I was cowering and crumpling up and cringing and literally on the ground.

The unfairness of it! The outrage that the doctor should share my personal situation, one that I had been so careful to conceal, even from extended family, one to which only my husband, son, and concerned professionals were privy. That she would actually discuss it with another person, and that I should be taken to task!

It maddened me and haunted me. I felt violated and insulted.

I knew my doctor was legally obligated to keep my information private. I wrote to my lawyer, sharing my agitation, and he responded with excerpts from the HIPAA web site (which puts down strict do's and don'ts for medical staff) about confidentiality.

I knew that my complaint or even drawing the administration's attention to the incident could cause severe damage. I had to keep quiet. I couldn't hurt them.

My outrage was on a personal level. The privacy that was in question was mine. Stark and personal. I had been exposed and hurt.

I held back and tried to reconcile myself to the whole thing.

I could understand that the doctor must have been thrown off. She shared what she shouldn't have, but then, she was human, and she made a mistake. The intention was not to hurt, but the result was devastating!

I didn't consult her for almost a year, only emailed her if I needed medication or a referral. I forewent a prescription refill because she demanded an office visit. And then I removed myself from her care completely and found another doctor.

It was a few months ago, more than two years later, that the worm finally turned. I wrote to her and told her I had been taken aback and upset about her sharing my personal information and situation. I told her that was why I had changed doctors.

She responded by saying she hadn't even realized I was no longer under her care. . . .

ONE WOULD HAVE hoped that friends would have understood the trauma and the transition.

Of course, there was the expected outpouring of sympathy, the wish to visit and possible indignation at being requested not to. I was not ready to be seen in my state.

I looked repulsive and felt miserable.

I was simply hanging in there, putting the figurative "one foot before the other" and trying to remain "steady on" in my mind and my life.

My life was dark. I was grateful for the caring, but there was such a clamoring in my brain that I was not open to visitors and talk and discussion.

I was humbled that people should care and was touched that aunts and cousins with whom I had not been in touch in decades were concerned and calling from across the seas.

But I was not ready.

Ironically, I am still not ready for a "condolence call," which is what my initial meeting with relatives and friends tends to be since the accident.

Unfortunately, that has meant a filtering process in my friends list.

While some have stayed by my side and have overwhelmed me with their understanding and unreserved support, others have given up on me. They

didn't seem to want to let things lie dormant. They didn't have the patience . . . or the faith.

I didn't and don't want anything from them. But they don't want me.

Is that a cause for worry or depression? Thankfully, no.
It's just disillusioning.

In the long run, it's a boon. We see people's true selves when their social armor is down—and I have.

I would have wished for discernment to recognize sincerity and true friendship. While it has come as a harsh reality and at a time when I might have hoped to be spared an added truth, I can only be grateful that I know now.

It gives me the opportunity to appreciate those who did come through and who have stood the test of time.

KINDNESS IS NOT necessarily something that we are born with or "achieve" as we grow up. Sometimes, it is simply thrust upon us—by life.

Experiences chisel us, transforming not only our character and outlook but also our demeanor. The harder the trials, it is to be hoped, the kinder the person who results!

It is when we are put through suffering that we start seeing others from a new perspective, as people who might be suffering as well, who might have their own story to tell. The fact that they haven't told it or that we don't know it doesn't make their experiences any less intense or damaging.

It is probably a person fighting his or her ghosts who comes across as asocial or short and rude. That is the very person we might be in danger of judging harshly.

When people confide their woes, our hearts go out to them, and we are overcome! We set out to help them and feel protective toward them.

Ignorance of someone's struggles shouldn't allow us to sentence the person to Coventry, to scoff, to segregate! It is our lack of knowledge that is to blame, not the person's inability to overcome pain.

So, isn't it better to simply be kind regardless?

We don't know what battles others are fighting, but surely we don't need to add to them!

Sent: Monday, October 13, 2014 7:59 PM

Subject: It seems unlikely

IT SEEMS UNLIKELY that perfect strangers can play such crucial roles in our lives, have a much more visible hand in our healing.

Maybe it is the unexpectedness of their kind gestures that leaves such an indelible mark.

Or perhaps it is the humble gratitude we feel because the goodwill was not a by-product of an existing relationship.

Or it might be the reaffirmation that we live in a kind world that can be so strengthening.

So many acts of kindness have touched my life. Such gratitude do I feel for people who have had a hand in rebuilding me. . . .

I feel humbled and beside myself.

FOR THAT TIME, those moments of struggle with life, with . . . destiny? They are one with us, totally committed and completely absorbed.

Emergency responders—firefighters.

Such selflessness, such dedication to just . . . saving!

Saving not just a life but a mind. Wandering through deep, dark dungeons as it traverses the long journey between hopelessness and relief.

Offering comfort as they put their skills and strength to one single task.

How does one measure their contributions, their "hand" in being our saviors?

That scale is yet to be made, but that surge of feeling of gratitude and humbling is in my heart.

Sent: Tuesday, September 30, 2014 2:09 PM
Subject: The care and

THE CARE AND the caring that the world is capable of is overwhelming. Humbling. From the person who came up to my car first—in either of the two accidents, an average gentleman who was simply a concerned witness—to the police, the firefighters, and the paramedics. Each person's compassion and help, even in just calling 911 or asking me where I was hurt, everything was significant and strengthening.

Who knows who made all the difference? Was the actual cog in the wheel or simply an essential puzzle piece?

Those were the actual accidents, where the gravity and the calamity were supported graphically, where the very sights and sounds lent to the tale of woe, and sympathy overflowed.

Yoga instructors and gym teachers who have been instrumental in helping me gain mobility, strength, and regain belief in my ability have had no visual aids.

Most of them don't even know my name, let alone my background. They simply saw a partially disabled woman trying to justify her presence in the class while doing her best to merge with the background and get lost in the crowd.

Encouragement came to me in the form of suggested modifications. I am grateful for attention not being drawn to me and to my inability to keep up.

Compassion was certainly there, but more empowering were the urges that we could do it, to push the envelope. It seemed that those words were for me.

While my family felt my pain and were hurting just watching me push myself, these strangers were encouraging me to push myself a little more—to become stronger.

There were times when I grit my teeth and others when a tear or two would escape, but I gave myself no choice. I had to fix things.

Physical therapists, orthopedic surgeons, and mental health caregivers fell way short of what I was able to get through my own striving and the guidance and urging of perfect strangers.

Not that the medical professionals were less caring, and perhaps they are way more knowledgeable, but they were still working as professionals to help with an ailment.

That the ailment went beyond the obvious physical one, and that the pain and the disability that resulted were not easy to diagnose was the challenge.

What blood test, X-ray, or CT scan gives us the true picture of the turmoil in the mind? Does an MRI work?

There is such a cacophony of sound and such a tangle of thoughts and emotions that identifying and untangling them would be an impossible task.

And what happens when the symptoms contradict each other?

I love my family but want to be left alone. Where does that place them or me?

Music sounds like noise, and being discouraged from walking too much makes me frustrated and irritable.

Quantifiable and understandable situations can be met with squarely. Mine was not one of those.

What was touching was that some of the most competent fellow students at the exercise classes, who seemed so blasé and were popular members of their cliques and who seemed confident, remote, and unapproachable turned out to be so very considerate and helpful.

I took the time to thank my instructors at different points and shared with them how helpful they had been. I did the same with a lady, a fellow student, who had given me some advice and pointers early on in my recovery.

I approached her almost four years after she had helped me. Just telling her that I remembered her and was grateful was so very meaningful to her. Her face simply crumpled, and she had tears in her eyes. She told me that it was, "the kindest thing" she had heard "in the longest time."
But it was she who had helped me! The kindness had been hers! I had simply recognized and acknowledged it.

Possibly, as we get caught up in our daily routine, we internalize everything and forget to recognize and appreciate any positive role that others may have played in our day, in our lives. . . .

I WAS BEHAVING like a spoiled child who wanted the very thing she had been denied.

I wanted to wear higher-heeled shoes than I had ever worn before and go to a spin class at the gym.

Pushing the envelope, setting more difficult tasks as milestones.

I was inflicting pain on myself in the hope it would make me better and stronger. I would get back to square one, and even that, with flying colors.

It was a stubbornness that didn't let me accept the fact that things don't always get back to the way they used to be, that changes leave marks and alterations.

A scar on the forehead may heal with tender care, but it will remain etched in the flesh—and in the mind—whose presence tells of battles fought, and often won, but for a price. A price that is more than just the physical pain. It also includes mental torture and strife. A shift in our environment and a change in how we perceive it.

I was taking on a torturous uphill battle. The exhilaration that victory would bring would be worth every bit.

I was certain I would finally get there. Everything would be within grasp.

I only had to reach out harder and longer. . . .

TO ACCEPT OUR shortcomings, our limitations, and to be comfortable with them, is probably the key to a much calmer life.

I kept striving to achieve more than I had in the past. Less than that seemed like defeat.
I would be a failure. . . .

I was like the pendulum that went to extreme degrees before it realized that to be centered makes for a more balanced life.

But, every step was part of the process. The desire to remain in charge, the denial that anything was out of the ordinary or that I could not take it all in stride, the withdrawal from the world when I felt incompetent, and the feeling of helplessness before I felt the terror that my life was no longer in my grasp.

A slow but sure plummet until the parabola began to form . . . with an upward slope.

WE TRY TO quantify our happiness, to make it comparative and superlative. What is the baseline, in relative terms?
To what or to whom do we compare? The person next door or the person we firmly believe is the happiest one?

On our radar, at least. . . .

More often than not, we quantify our happiness using those people as the yard sticks!

A shift in perspective.

The number of people we can notice, by observing more closely and being more sensitive, who might be "being" happy as a firm "choice."

It's humbling to know that the most well turned out "fit" lady in yoga class is actually wearing a wig, because chemotherapy caused her to lose her natural mane, or that another who looks like she stepped out of the pages of a fitness magazine, gym clothes and all, mentions that she can't raise weights above her head because of her recent brain surgery.

To watch the person who uses a walker, hobbles up to the exercise bike and then proceeds to heave himself onto the seat and take a spin class. Or the elderly lady in the locker room whose hands shake so much she can't even undo the buttons on the sweater she needs to take off to take the water aerobics class.

And these are simply physical handicaps. We haven't even looked into

people's lives to know of their emotional baggage.

There's nothing like looking at what life has meted out to another to change our frame of reference, to make us thankful for what we have, to be happy. . . .

MY STORY DOES not have to end with, "and then she went back to teach at the school she founded, a non-profit that helps children with special needs and those who are less fortunate" . . . 'til glory come—literally!

Just because I didn't go back to a regular job in a profession I loved or find something else meaningful and stimulating to do does not mean that I lost.

I don't have to prove that I am not a coward by getting into the mainstream and being an outstanding success at it.

I feel no pressure to prove anything, and I think this is a conscious decision, one that I needed time and confidence to make and to be comfortable with.

Now I feel that I may be on the path to "arriving".

My story does not have to complete a full circle to be complete.

SO MUCH HAD I internalized myself—so divorced was I from my surroundings—and so cut off was I from the rest of the world that I lived in a vacuum of sorts for a couple years, perhaps longer.

It was during a psychologist appointment that I agreed that it was a nice day—automatically—and then made a sudden realization.

It really was a nice day! I agreed!

It was when I saw a look of joy and triumph, a kind of "breakthrough" expression on the psychologist's face that I realized . . . I had made a breakthrough!

I had felt a nice breeze as I walked down the sidewalk. For the first time in a couple of years or more, I had been aware of something so . . . ordinary, something that had stirred my senses and given me pleasure.

The gratitude I felt was not for a beautiful day. It was for my ability to actually notice, recognize, and find pleasure in one. A simple joy that I had been robbed of and that had returned with a wealth of meaning.

FLOWERS ARRANGED AROUND the house (mostly from the backyard), a sparkling clean home, a routine—walking our puppy, yoga, getting dressed, waiting for my husband and son to come home. Familiar. Slow-paced.

Long evenings. Long, familiar vacations with our little dog. An undemanding routine. Predictable. Uneventful.

Mundane yet calming.

Healing and Enabling.

The ground beginning to firm up beneath my shaky feet. . . .

Part II

CHOOSING TO BE FREE

Sent: Thursday, October 2, 2014, 7:22 PM
Subject: Dark tunnels are

DARK TUNNELS ARE associated with light at the end. It is also darkest before dawn. So does the human mind comfort itself, and justifiably so.

If hope weren't the necessary ingredient in every tale of sorrow, there would be no tale to tell.

I had had an accident and lost my job in a span of a couple of months, hit rock bottom—or so it seemed—as I entered the new year.

Things could only get better. . . .

I was ripe for the picking, the correct forum and luminaries with motivational speeches of struggle followed by miraculous achievement and success while serving others. I had found the perfect recipe!

On a March day in 2009, with free tickets from my husband's work for a seminar that included presentations from leaders like Colin Powell, Rudi Giuliani, and Steve Forbes, we ended up buying two discounted workshops—one on real estate, which promised to teach how home mortgages could be paid off in seven years, and the other on stock trading.

One thing led to another, and hope and a stirring of faith made me make what was a deliberate choice but also probably the biggest mistake I have ever made in my life.

In my magical story, there was a "fairy godmother" who made everything right—and there he was! This gentleman who had shared the stage with world leaders, who told stories of profiting through serving others and to whom our

family, just the three of us, was very special!

He was a father figure for us, the grandfather my son had never known, a loving uncle, and an advisor and mentor for the family. All in one stroke!

Such sincerity and such a ready solution to every problem we had—that I had.

He took us under his wing

I felt blessed. I had found my calling. Here was the person who understood, who had great sympathy for me, who had the solutions for which I was looking, who would reinstate me in the world. Things would be better than ever before.

We signed up for the most comprehensive package his company, a real estate company, offered. It included classes, seminars, mentoring, and lifetime guidance.

But we were not his students. We were family! From the moment he suggested we all go out for dinner together.

Over the next few months, he was a houseguest several times. My husband travelled across the country to help him. Even my son travelled with him to his seminars, and we took classes from him and his son in various cities.

Financial information that I would balk at sharing outside of my immediate family, we shared with him. In detail. Unhesitatingly. Our faith was complete!

Not once did we stop to think, as we would have a few months prior. We were behaving in a manner that was diametrically opposed to what was normal for us.

And I was leading the family. I was sure this was the answer, what I had been waiting for, the "reason" everything had happened—accident, layoff, being at a crossroads. . . .

When he suggested that real estate would be too trying for me and an investment in a highly sought-after and patented technology would be a much wiser choice—it was his venture. He owned the rights, he could let us in on it, as a favor, because we were special—I agreed, with grateful appreciation.

Whether it was my husband's faith in my decisions or his desperate desire to see me get back in the mainstream, his support was unquestioning and unstinting.

Retirement funds, savings, a new home loan, we lapped up all the advice and poured in all of our money. Just like that!

We were the cautious and skeptical kind of folk who would eye every advertised scheme suspiciously and look askance at any mention of investments and handsome returns.

And then, just like that, we had taken our biggest leap of faith ever, because a person had been introduced as part of an outstanding crowd and had proceeded to pique our interest with a few interesting possibilities and then interacted with *just* our family and promised to take us under his wing. "I'll help you. . . ."

My judgment wasn't just impaired; it was a wreck!

Such was my faith in him that, when his own manager inquired about our decision regarding investing in the suggested joint venture, my response, in writing, was that my decision would be guided by him—our father figure!

Little did I know that rock bottom was still a long way off. All of our money

had to be lost as part of the downward path. That happened, too, within a year of the first accident and lay off.

All the bank transfers—the retirement funds converted and transferred, a new home loan, the savings—every bit was siphoned off with requests for urgency, "because the returns would need to start." Soon!

Three weeks after the final transfers, I had my next accident, when a big rig crashed into my stationary car on a freeway exit, pushing me into 5 cars ahead of mine, then swerving and pushing me into the guardrail, and finally proceeding to crumple my car until the truck engine was running above my head and my fuel tank was on my back. . . .

I HAD YET to hit rock bottom.

The inability to bounce back from the second accident was not my only major stress. All of our money seemed to have gone into a black hole!

The promised returns were not coming in, and the promised acquisitions (that we had been given information about by the scientists and lawyers working on the venture in a meeting in Calgary) had not been made. There seemed to be no progress at all. All we heard back in response to our hesitant queries was that the plans had changed and more investments were needed to move forward. And, of course, they would be so lucrative that our returns would be proportionately higher.

Conversations and interaction with him continued with caring tones and concern. With my second accident and the trauma that followed, there was so much advice, follow up, and support that it was impossible to even conceive of anything remotely hurtful.

It was when I began to ask about the lack of returns, despite an extended gap of time, that I saw a different person. The same gentleman who had been kindness itself—who had cooked in our kitchen, walked the dog with my husband and discussed my being in a "dark place" and how they needed to help me, as a unit, who picked up my son from school and insisted on getting the groceries—in an instant, took on a Mr. Hyde persona.

He began shouting on the phone, and I found myself apologizing for asking, berating myself for not having faith, for not understanding that "these things take time."

My self-confidence was already down in my boots; I was an easy prey for disparaging remarks. I actually agreed!

Sent: Thursday, October 2, 2014 7:59 PM
Subject: We asked if

WE ASKED IF we should take our money back, simply withdraw it. It had not been put to use yet, because nothing new had been acquired. Should we just get out? Forget about trying to invest?

We received an "Exciting Update and Capital Guarantee," a document that promised shares and profits in a new company based on groundbreaking technology, simply because we had chosen to invest with him. This would be in addition to our actual investment, a thank you, a windfall!

This was promised not only to us but also to each and every person who had ever taken advice from or invested with him.

Of course, we were touched—and impressed.

And then we received a verbose newsletter, with a casual mention of a "waiver specific to him."

We, and everybody else, had to sign a waiver with regard to any possible litigation against him in return for the gravy promised in addition to our pound of flesh.

Of course, we weren't signing anything. But I began to feel chilly, cold. . . .

I COULD ONLY beg for my money back, and I did!

I had been clinging onto rocks against a raging sea, and the rocks themselves seemed to be taking on the appearance of a monster. I was certainly on a rock *and* in a hard place, and I was terrified of turning on it. It was fear that kept me there, paralyzed.

I received emails from his manager with reassurances.

I was willing to be reassured. Anxious even. I wanted to believe!

New plans for the joint ventures were underway. Some large sums were needed and expected. The plans would become a reality, and the returns would start. It was just a case of a slight delay!

Days, weeks, months . . . prospective investors from China and France, money transfers and entities set up in the UK and Switzerland. . . . The money would be made available. The acquisitions completed. The projects underway. And returns would start.

I received many emails that kept my spirits from sagging completely. But dates reached their anniversary, and the situation moved no further. Yet another set of promises, yet another timeline. It was becoming cyclical.

Something was wrong! Suspicion was building upon the fear.

I began to search, and I unearthed a can of worms!

There were numerous investors, suffering and helpless. A $10 million lawsuit by "mostly elderly victims" was filed in Utah and another in Arizona by "unsophisticated and unsuspecting 'student' investors" who claimed to have "been suckered" for "millions of dollars." And more. His former friends, colleagues, instructors, people who had, earlier, written testimonials for him online.

He had a list of lawsuits against him!

You only had to know where to look. It was public information, on the web.

Random and unexpected, it was easy to brush aside, to overlook. But piecing it all together told the actual tale.

At least I had one thing to my advantage—time! And motivation was at its peak!

I searched and dug and pieced together. I sent him links to articles and lists of lawsuits against him, asked about them.

Lawsuits had been, or were being, dropped, "taken care of," is how he put it. He simply brushed it off!

It was appalling!

To be wrong, to make a bad decision, all is forgivable even if the price is high, because it's a genuine mistake. But to be leading people blindly, playing with their faith, fully aware they will probably lose their money but spurred on by the desire for your own profit and, perhaps, that of a few associates (by virtue of them doing some of the leg work), to have a callous disregard for the fate of others' money, money they invested because they made the mistake of believing. . . .

This was just wrong!

And I couldn't put it right.

I was disgusted. We felt cheated, not just out of our money but also our belief in someone we had thought was a genuinely good friend. He had seemed like family! We had welcomed him into our home, trusted him with all that we had.

And here we were locking the front door on a street with friendly neighbors. The irony!

I felt helpless, but not hopeless.

I had no plan, no clear train of thought, just a need to put an end to this injustice, to make people see so that there would be no more victims, people like us who had lost not just materially but also the confidence to put their faith in others.

I stopped communicating with him, as did my husband and son. We would acknowledge his texts with a polite greeting and leave it at that. We could sense he wanted to get things back to where they had been, reinstate himself, but we didn't want the friendship—if it had ever been that. We were hurt, and I was hurting.

I had just made a poor decision, placed my faith in an undeserving individual, exposed my family to hurt, sheltered an enemy—literally—and led us to financial ruin.

Now my downfall was complete!

THE MANTLE THAT had seemed comforting at first, a security blanket, had proceeded to smother and suffocate until its weight bore down upon me and was impossible to crawl out from under.

There was no crack of light in the dark folds, no opening.

I felt trapped. And I was!

COWERING CRUMPLED YET alive was my situation inside a tangled car. Parallel to that was my plight two years later with regard to our family's finances.

I felt sick to my stomach and did my valiant best to summon up the makings of a smile when my husband tried to laugh it off with an "earned it once and will do so again" reassurance.

What was done was done and certainly couldn't be undone, but I could do what I felt driven to do—to expose the reality, to make sure that no one else became a victim.

I had to take up cudgels on behalf of others. Nobody else would get into the same predicament, not if I could help it.

And I did!

I felt neither guilty nor hindered by obligation.

My indignation became my strength. It released me!

I began to scour the web for information on upcoming seminars, put together a list of pertinent sites that would tell a self-explanatory story. I didn't have to share any personal information, my own plight, or any opinion, just plain facts, right off the web.

"The pen is mightier than the sword." Never had this adage resonated with me as it did when I made desperate attempts to make the world aware.

I contacted news channels and newspapers in every city in which the seminars were held. Ironically, when I contacted the ones in Phoenix, one of the scheduled cities, and I was able to talk with a reporter who had covered similar stories and bring to his attention lawsuits that involved Phoenix residents— real estate developments that were the source of some of the litigations that were also in Phoenix—and sent him printouts of the same by registered mail, he refused to do anything at all, not even an editorial of sorts as a discussion about a seminar that was coming to town *again* and that had had some hiccups the last time around.

He and others I contacted had the same attitude.

"Has he been charged? No?"

They couldn't cover anything for fear of being sued.

ABC News, Mercury News . . . I sent the information to Anderson Cooper at CNN (AC360). I wanted to "Keep him Honest." No luck at all.

I talked to a TV news director in Raleigh. He asked me to send the printouts. In my follow-up conversation, he said it wasn't important enough. There was a hurricane coming, didn't I know? That was "breaking news." Extremely stressful, too!

What about the human hurricane that was headed their way and would destroy homes, fling around their lives, and cause irreparable damage? The one in plain sight, advertised and sold out? You could see it without even looking at the weather map.

Its intensity could be gauged, its ill effects predicted, and a plan for relief put in place, simply through creating awareness.

My efforts were dogged, the results nil. All I have for them are the call log on

my cell phone and the receipts for the registered mail that I sent to multiple news agencies in every listed city.

I refused to call it quits. I put together a list of the websites and headlines, with excerpts from the sites—public information on public sites that told the story clearly—and pasted, right on top, the site of the business seminar that was the launching pad for this person. His platform, his springboard, his breeding ground.

Then I proceeded to find the contact addresses of the luminaries with whom he shared the stage. Rudi Giuliani had his personal site at Giuliani Partners, and Steve Forbes had a contact address at Forbes.com. General Colin Powell had contact information on his Facebook page. I tried to contact Larry King at CNN, too, and was told to send it in as a story tip. I did, directing it as information for him.

Nothing had my name on it. Nothing needed it. Of course, had any of them chosen to reach me, they could have done so easily. I sent it all from my desktop at home.

But nobody did. They didn't have to.

I knew to whom I was reaching out—men of integrity who prided themselves on standing up for what was right. Fighting from the moral high ground!!

How effective my efforts were, if at all, I have no way of knowing. What I do know is the seminars no longer advertised these speakers. One by one, they dropped out.
Scheduled seminars were postponed and then cancelled. New speakers came on board. Carly Fiorina was one of them. I reached out to her as well.

The last couple of advertised events were cancelled. I have no way of knowing the exact reason—not yet, at least!

THE UGLIER THE monster, the more likely it is to rear its head again, and it did!

No sooner had these events in the USA come to a grinding halt than the international speaking circuit became his new stomping grounds.

My crusade moved to foreign lands, but with the same compelling force.

My redeeming factor? He never told me that he was speaking in all those cities in the USA or elsewhere. If I had received the information from him and sneaked behind his back, I would have felt guilty and mean-spirited. My searches were my source. It was public information. I just needed to be dogged.

I realized he was speaking for a different company now, one with headquarters in Singapore and Australia. I contacted the embassies for both countries.

While the Australian embassy in Los Angeles would not entertain my efforts to give them information because I was "not an Australian citizen, Ma'am," the Singaporean embassy in San Francisco had a rather wary and hesitant lady who took down some information—reluctantly—after I praised Singapore's high moral standards. But in my follow-up call, she brushed off the entire matter. She had looked up the main website and didn't see his name on the list of speakers. It didn't matter that he was being advertised for an event with the company's subsidiary in Australia. Singapore was not responsible.

I called the actual company offices in Singapore and Sydney and managed to speak to the assistants of both company heads, who themselves were not

available. I was able to direct them to Google searches, the series of key words that brought up all the links that I felt were pertinent and afforded sufficient information. Pleased with my efforts, I was certain I had been effective. But once again, I had not!

It was with Sir Richard Branson that our friend shared the stage next—in three cities in Australia!

Touted as a real estate expert from the USA, he was there to teach people to succeed "on the shoulders of giants." He offered a deal on workshops (just as he had in the US) but with a bonus—a FREE seminar in the USA to research and buy property there at a fraction of the price, because the market was right and the return would be great.

I saw excited attendees "tweeting," asking if people could lend them money to go to the US for this "amazing" deal. My heart went out to them.

I contacted the ASIC (the Australian counterpart of the Securities and Exchange Commission or Office of Fair Trade), filed multiple online complaints that listed links and activities pertaining to him in the USA and Australia, made phone calls to the ASIC and explained the gravity of the situation repeatedly.

I could tell Sydney time just as easily as my local time. I had become so adept at the calculation I was living in two time zones. But to the ASIC, I was still just "noise."

Irony? When I Googled his name, "real estate seminar," and "Australia," I came upon two articles from 2004—nine years prior—when he had gone to Australia and spoken in a similar forum. The articles warned Australians, and the consumer department pointed out the flaws.

A eureka moment!

Searching policies and scams, I came upon the ASIC's own money scam alert page that actually referred to the precise seminar (in 2004) offered by this very gentleman and three of his associates. "FOUR FINANCIAL SUPERSTARS," is what they had called themselves (no names, of course).

The fact is, he was being used as an example of "scam artists" from the USA, and now he was back in their country, turning up like a bad penny, and being advertised and promoted by their own country's business community!

It gets worse! A video of him was posted online in which he promised to show his students how they could use their "self-directed superannuation" to make profits, promising he would "reach into" their "souls" and help them "believe" in themselves. He would be "there" himself.

The funny thing is, it didn't say "where." Cryptic at the very least. For a reason? Covering his tracks?

I Googled "superannuation." It's a retirement fund in Australia!

So, he was doing in Australia what he had already done in the USA—with disastrous results in our case and in the case of so many others!

But giving advice on SMSFs (self-managed super funds, i.e. a self-directed superannuation) without a financial license is a criminal offense in Australia. I know it, because I researched it. And then I double and triple checked with the ASIC officials themselves.

What makes Australians excellent targets for overseas scams is the fact their authorities have no jurisdiction over money that has left their shores. Their money scam alerts reiterate this limiting fact repeatedly.

And here he was, going back to a country where consumers had been warned against him several years ago, to share the stage with a world-renowned

business leader like Sir Richard Branson, flouting the ASIC's own scam alert, and breaking the law.

I got through to Greg Tanzer (the ASIC Chairman)'s office, connected with his personal assistant, and made wonderful headway. I was assigned an officer, an actual person who talked to me and pulled up all the information I had provided over the previous weeks, online, over the phone, and by registered mail, and took matters in hand.

I contacted the Australian Treasurer (a member of Parliament and the overseer of the ASIC) and, later, connected with the new one when there was a change in government. I was able to get my information through to the activist who had made such a hue and cry about this very person in 2004, whose articles had helped me tremendously in finding a thread.

I sent the set of links to every company (mostly Australian real estate companies) that had speakers scheduled to share the stage for the workshops that followed.

What the ASIC does, it keeps confidential, but Australian ABC News did carry warnings from the ASIC about SMSF scams and property being offered in the USA as part of them.

The next seminar was in South Africa. I could not find any information that told me whether or not he would be speaking, but the pattern and most of the speakers were exactly the same.

I had a hunch, and I made a call. He must be part of it; they simply weren't advertising him. I had seen no changes on the Australian site about his upcoming workshops. The show had to be continuing.

I contacted the South African Embassy in DC. Polite and kind, these officials were an entirely different cup of tea. They gave me the cell phone numbers of

the higher officials and put me in touch directly with the Deputy Ambassador of South Africa to the USA. Courteous and attentive, he heard me out, spoke to me several times, looked into my emails, and took notes as we spoke. I had to admit I had no proof that the panel would include the person I was calling about, but I was quite certain it would. Even that was noted, respectfully.

I had been introduced to the Deputy Ambassador of South Africa to the USA as the influential person who could contact their president personally, should he choose to do so. His position was noteworthy.

I was hopeful, waiting for action and to hear back, as he had promised.

The two-day seminar was held, as advertised, in Johannesburg, and I saw proof that my concerns were justified. The same person spoke, and the same pattern followed—selling workshops that included a free seminar in the US and touting investment in the USA "without even using South African banks for transaction and transfer" or "breaking any laws" in South Africa. It's actually available on an online video that promotes the program. He even appears in the video himself.

I was aghast. How could all of this have gotten past the South African government? I had given them a heads-up and all the details via email and over the phone!

I received a polite note from the deputy ambassador. It said he had forwarded the matter to the relevant authorities and would keep me informed. "Yours kindly. . . ."

I wasn't going to be put off. The UK was next. I contacted the fraud authorities (Action Fraud) and lodged a complaint online and over the phone. I followed up with phone conversations, repeatedly citing the original complaint number as a reference.

I filed a complaint with the police in that part of London as well (during which I realized the famous Scotland Yard had been renamed "Metropolitan Police!").

The member of Parliament was rather less accessible and certainly not accommodating, and the Office of Fair Trade could not be bothered.

Hilary Devey and James Caan, entrepreneurs and TV personalities, the local luminaries at this event, were my best bets.

I contacted the public relations/publicity manager for Hilary Devey first. A phone conversation and an email exchange follow-up ensured that I got my message across. Emails to James Caan's staff were acknowledged promptly.

I have to admit that nothing gave me a clear picture of what I was able to achieve, if anything at all.

But, somewhere, somehow, something clicked. The event details put up a day prior to the event were different. They did not feature his name and picture anymore. But that was not proof enough.

I contacted one of the event organizers via email. That's when I got the confirmation I needed! He "did not speak at the event," is what I was told. No details, but then, neither did I expect them, nor did I care.

The Netherlands came next. A set of calls to the embassy met with no response. Emails to the government were acknowledged promptly, but there was no evidence I was making any headway.

I was getting tempted to give up in despair, but I continued, striking out as powerfully as I could. And then I got a response—not from Sir Richard Branson, though I should note I have never seen him advertised at any of the events since—but from Tony Robbins' assistant. She thanked me for my

efforts and emails and said she would work on them with their legal department but would not be getting back to me regarding the developments.

I whooped for joy! I needed action, not information!

Within a week, on October 15, 2013, I got a call from our erstwhile "friend."

"They've fired me," he said. He sounded menacing when he said that "someone" had been "giving information" about him and that that person would "be sorry." It was obvious he suspected it was me. But then, he has so many victims, it would be hard to narrow down, let alone pinpoint. Not that I cared!

I murmured that I was sorry to hear that.

He had never told me that he had been hired. For all intents and purposes, I wasn't even supposed to know to what he was referring.

None of the information that I had brought to the attention of the media and the authorities about his work or his seminars (in the USA or abroad) had been from him. Everything that I researched and followed up on, every action was a product of my own effort.

I had no reason to be sorry. It was simply a polite response.

My crusade had made a mark!

IT WAS RELIEF rather than exhilaration that followed.

I felt absolved in some strange way, and in some small measure, as if I could try straightening myself up. I didn't have to be crumpled anymore. The roof was no longer an oppressive, unyielding force.

My family's personal financial situation was no better off—our money was still gone!

"Ironically," he had said when he called me that October day, the person who was "doing this" was "harming" him or herself. More seminars meant more workshops, and more investors. New investors could "replace" us in the investment, and our money would be returned to us. It was that simple!

He was pointing out just how "self-destructive" I had been.

I already knew that! I had known it all along when I proceeded to be an impediment.

All three of us had been cognizant of the facts and the price of my actions, and I had my husband and son's complete support.

I had felt driven, a pressing need to save others from a situation we were in already—inextricably, it seemed.

We were trapped!

Yes, I had walked into it of my own accord, but that didn't make the outrage

any less. In fact, it put the onus of the blame on me, to a larger extent.

My judgment had been colored and impaired. I berated myself. Saving others was, in fact, helping me.

The price is possibly never getting back our savings and retirement funds and continuing to pay off the new home loan, but the alternative was to remain passive, be party to the crime, simply by virtue of being aware and turning a blind eye.

The choice was simple.

Sent: Thursday, October 9, 2014 1:12 PM
Subject: The FBI the

THE FBI, THE SEC, THE DA'S OFFICE. My blood runs cold, and my hands feel shaky.

"Nervous anxiety" is the term I would use to describe how I feel when I work with any of these agencies that are now helping us find out where our money went.

Helpful and professional, they genuinely care, but their eyes have sympathetic understanding and . . . regret? Pity?

They have heard this story before. There are times when I feel they would almost like to supply the rest of what must have happened as we begin recounting the tale of misplaced faith and a would-be "savior" who shrugged off a mantle to reveal another diametrically opposed role.

Part of the tale, a couple of questions, and a skimming glance over a few of the documents. "Your money is not there." Their confidence destroys our hope.

"By the time we get to these kinds of people and conclude the investigation and seek justice, the money is generally gone."

This is what each one of them has told us. The message is the same; only the choice of words is different.

The inability to get our money back seems almost as final as the impossibility of being able to trust and open our hearts and home again.

The greater and more damaging loss? That's debatable.

Part III

REDEFINING ME

IT WASN'T A roadblock or a pitfall in my road to recovery that threatened to become my undoing. It was my recovery itself.

I had alienated myself from the world. It was involuntary to a certain extent but also deliberate. I had felt incapable, miserable, irritable. I simply wanted to be left alone.

I had sympathy and support, a great deal of it. I had such dedication from my siblings that one of my sisters wanted nothing more than to see me get back into the mainstream.

"Take up any job, do anything. I'll take time off from my work and drive you to your work every day for a week—ten days. I'll wait for you outside and drive you back at the end of the day."

This was the level of encouragement with which I was blessed all around. I was cocooned.

If so, why was it that, as my recovery led to my taking charge again, there was discomfort and suspicion? Why were hackles raised and the withdrawal and unfriendliness so constant and deliberate?

Why was my simple act of helping one of my own sisters, who was going through a period of self-doubt, condemned by some as a deliberate attempt on my part to oust those who had been helping her so far?

All I had done was persuade her to make an effort—to make the most of her appearance and establish a daily routine—to take charge of her life! A

renowned professional and a toast of society in her heyday, she was suffering from a lack of identity due to personal reasons. She had been "hiding". I could see it and I could relate to it, and I had acted to help her, instinctively.

That's it—that's all of it! My help might have been insignificant in the bigger picture, but it was significant in its immediate effect and visibility.

And I was accused of trying to steal the limelight—quite unceremoniously and in a group email addressed to the entire extended family!

My reaction was immediate. I apologized. I wrote again and explained myself further, and apologized again. I tried to keep the tone calm but there was a brittleness in me—I was in danger of shattering. . . .

The crippling disbelief—*This is what they think of me?*

I felt humiliated—my anguish was extreme. The shell I had been rebuilding was only half formed, flaccid and weak. It didn't protect me.

Neither was I friendless, nor cast out by all. I had the good fortune of having other members of the family too —those who stepped up swiftly to shield me, whose outrage was for me!

But accusation can be devastating. I couldn't straighten up, there was no light as far as I could see.

I had been through some trials, reflected on them, and reconciled them in my mind:

My modesty being compromised on the freeway had been part of a routine, necessary to a situation.

My being made redundant was a department's decision and external to me to

a large extent.

My financial ruin was my own responsibility.

But how was I to redeem my dignity, my standing, when those who had cast a slur upon it were some of the same people who I grew up with, whom I looked up to . . . who had always watched out for me, "the youngest in the family"?

I HAD MADE myself vulnerable, easily affected by my extended family's opinions. Any disapproval and disharmony were suffocating and "noisy." I felt confused, disoriented. There was such clamoring in my brain!

Is it difficult for some caretakers to accept the "equality" that recovery brings with it? A growth that they had fervently hoped for but which gets into their own space?

Do the same hearts that well up with grief and a desperate desire to help the "victim" experience a change of heart as the dynamics change?

Are the reactions to the recovery ambivalent sometimes?

Where does that put the "victim"?

Was I justified in making a "comeback"?

A constant nagging and despair filled my brain, even as it tried to find rest in sleep or concentration while driving.

THE HARDER WE fall, the higher we rise. Newton's laws explain the gravity, the momentum, and the resultant upward motion, but that upward journey has so much resistance working against it.

Gravity and drag impede us as we attempt to take off, to fly, to soar.

Our wings have not been clipped; it's just that they lost the lift that was holding them up, the confidence that makes us stay afloat.

That lift and more is given readily and whole-heartedly, given by those who care, those to whom we are precious and who believe in us.

Sometimes it is simply timing that makes a simple gesture of kindness result in a huge leap, one that stands out in its effectiveness.

Surely there need be no accusation or feeling of guilt at having made such a positive impact, which has made others pale in comparison?

True, we are the ones who inflict guilt upon ourselves or give others the license to do so, but aren't we all born human—vulnerable, sensitive, and dependent on the approval of those who create our environment?

Didn't our upbringing and disciplining depend on this feedback from our caregivers and family?

So, when is it that we call it quits and decide that the opinions of the very same people are inconsequential and have no bearing upon us?

Sent: Saturday, September 27, 2014 5:23 AM
Subject: Just how far

JUST HOW FAR does one allow oneself to be weighed down by family dynamics?

Do relationships and the obliging deeds and kind sacrifices they bring with them give people carte blanche to treat us differently? Does our immediate family carry that burden, too?

Where do you draw the line and stand up for yourself?

Yes, relationships are important and should be maintained, but does that mean our mental peace and self-respect should be an offering to the sacrificial fire because it would be wrong to forget past obligations? Or because we're related? Or younger?

The sheer age factor leads to the help, and the helping hand often comes from elder siblings.

Is being younger a yoke for us to bear?

Should we take no favor, no help, because the price to pay might be exponentially high, simply by virtue of having to grin and bear being wronged as a "return gift"?

At what age and stage do we learn and start practicing that?

Until a short while ago, the same people were our homework help and fashion guides. . . .

AS I SUFFERED, struggled, recovered, strove to keep my head up and then sank into a deep gloom before taking charge of my own "getting back," I had only one person to deal with, to worry about—me!

I was wrapped up in my own pain and struggle, physical too—but mostly mental. My self-absorption continued as I attempted to come alive again. To me, I was the one who needed "working on," and I did work on myself.

Somewhere in the course of my pursuit, I managed to step forward, become visible. I probably made some caretakers feel unnerved. It might have seemed like a slight—that I was spurning them or even usurping their roles. My healing had been sincerely hoped for—but its effects affected their role directly.

Reaction set in.

Looking back at the sequence makes for such a clear tracing of what might have happened, but living through it was full of confusion and heartache. I had to learn to cope with a completely different and much more personal aspect of life.

My husband and my son were my rock. They saw me agonize, brood, lose heart. They sympathized with me constantly while trying to make me see the entire picture in a different light.

The shift in perspective had to come from within me. I agreed. But to accept and actually live the shift is what it's all about. No one else can help with that.

My challenge was to remove myself from the equation, to separate myself from others' perceptions and reactions. I had no ownership of those.

It simply wasn't about me! It was about others' coping skills, personal to the people themselves, not my responsibility.

But it was so hard to put theory into practice . . . they were my family.

THE GROWTH HAD to take place within me. I was responsible for my own vulnerability. I was the one who had given the "strings" to others. A jerk here and a pull there, and I was falling apart, my world was upside down.

True, my heart had gratitude and appreciation. Respect, too. But what I was experiencing and displaying was subservience. My vision and my judgment were clouded.

I had been showered with love and concern while I was obviously in need of the same. For that I should have been grateful.

I had the reassurance that I always had extended family for support. For that I should have been appreciative.

But I had been convinced that I owed them! And I was trying to repay the "favor" by abdicating, keeping to the shadows, showing deference rather than a healthy respect.

Initially, it was the result of a lack of self-worth. Then it was due to a pathetic desire to please. If I stayed "down," I would be playing a part that kept everyone happy—or at least comfortable! My interaction and emails strove to express my appreciation—grovel, even. That was my "solution" to any resistance and displeasure.

I didn't have the courage, or the will, to stand up.

I had "grown back". The dynamics had changed! Why was I apologetic instead of exultant? Why was I trying to brush my "re-entry" under the carpet

as if I were guilty? And, why was I falling apart because of "what they thought of me"?

I am crystallizing thoughts, coming to terms with situations and addressing fears and failings that had resulted in many issues that simply would not have existed had I been more secure and comfortable within myself.

My insecurity had been my failing. That I had allowed it to make me writhe had been my choice. And I am just as capable of choosing against it!

It took much agonizing and debate to recognize the simple truth: I have complete ownership of how I feel. It is my right, and, it is entirely *my* responsibility.

It all begins with me. I am the one who has to reinvent—and then reinstate—me.

Part IV

A DISCERNING HARMONY

ONE CAN COUNT on one's fingers all that is most important in life.

Just one hand will do, generally. Those who are more expansive might use two.

For me, just two fingers are enough: family and contentment.

We are blessed with the first, and we achieve the second by being happy with the first.

That sums it up!

A span of a few seconds and a blinding crash—that resulted in crystal-clear conviction and answered a question that might have required much thought otherwise, even moments before the accident.

What is most important in life—to me?

That topic is no longer up for debate.

A SISTER-IN-LAW CALLING 911 frantically on a second line while she tried to get me to tell her where I was. The GPS locator. 911 told her to keep me on the line.

I'd simply pressed "5" on the speed dial and shouted that I had had an accident. My work was done—for the moment. I couldn't have done more even if I had tried.

Such was my support that within minutes I had a brother trying to approach the site. He couldn't spot my car, of course.

It was under the lopsided truck. My brother didn't even stop to consider that could be me. He was looking for a slight fender bender, a paperwork annoyance.

He told me, much later, that he had been driving on, looking for where I was, where I had had an accident. And then, as he did, he caught a glimpse of grey. My car was just visible—under the truck.

"He was shaking," my sister-in-law told me. She was with him in their car, waiting. . . .

My other brother drove to the site immediately but was unable to get near it. Followed directions and parked behind the fencing off the exit ramp. Tried to look through the bushes.

He couldn't see the car. Just the truck and the firefighters. Completely involved. Running around. Shouting to each other.

Phone calls to my husband, almost 8,000 miles away, asleep.

"Expect the worst."

The hotel sent a car ahead of him to the airport to get clearance. His assistant got him on the first flight.

"Just how soon can you get to the airport?" was her only question.

His overseas office staff came immediately to pack for him, to accompany him to the airport. His suitcases were unevenly packed—one was overweight, the other empty. He forgot his cash in the hotel safe.

Nothing was a concern.

From the hotel manager to the airport personnel, sympathetic to a man. Focused on just one thing—getting him home to his wife.

My sister had left her patients in a fellow doctor's care and rushed to me, calling her husband, waiting at a nearby exit. The traffic was too backed up to get anywhere close.

My other sister-in-law was already picking my son up from school. She didn't need my message. They had it all under control.

Two more sisters were on their way. One was boarding a flight, and the other getting out from work. My mother was waiting by the phone.

Their agony, the uncertainty. . . .

My brother tried to approach the accident on foot . . . The police wouldn't allow it...

"That's my sister in there."

They wouldn't allow access, not even getting anywhere close. But they did say, "She's alive right now."

The reassurance was horrifying in its very attempt to reassure.

My good fortune, to have such a safety net. Such support. To have people caring, rushing, helping, waiting, just like the ambulance waited, because they simply couldn't reach me, couldn't get me out. . . .

"MOM'S BACK!" Shining eyes. A wide smile. And then . . . a clumsy hug.

I had just yelled at my son for the clothes he had left on his bedroom floor.

How amazing that my getting angry was such a relief! He actually looked happy, very much so.

Mom just hadn't been there, not since he was a freshman in high school. Not for the rest of high school. He was glad to have her back. Finally!

"Mom's back!"

The words echo in my brain.

How simple. How telling. . . .

IT'S BEEN A journey from simply trying to cope to surviving and then existing, pushing people away, putting a glass wall around myself.

And then, stepping back into the world, I felt it on my skin. Sometimes it was warm and fuzzy. Sometimes it gave me goose bumps. Then it was prickly and it hurt. But I was cocooned by those who loved me. My husband and son, my foundation.

And right behind them, the retaining wall, my two brothers.

My mother-in-law, kindness itself. My greatest sorrow is that she passed away while I was "gone," before she could see me come alive again.

My husband's younger brother, my brother-in-law, whose first question in every conversation is, "How is your hip? How are you recovering?"

Solicitous, concerned. And his wife who keeps trying to make me the goodies she knows I used to enjoy. And, my husband's elder sister. Such kindness and nurturing. Watching out for me. . . .

My mother, silent in her understanding, and my sisters, those who live close by and those who are far away but close to me nonetheless.

Some very dear friends from our yesteryears.

And our dear little dog.

I have had every support—such caring. I am blessed.

DRESSING UP WITH almost painful detail yet getting back home and promptly into pajamas the moment I am alone, with the exhausted relief of a trying job done.

These are the two lives I am leading right now.

I stress about sticking to the first one for fear of being swamped by the second.

Props are important. They help, not so much the image as the inside. . . .

That still tends to curl up within itself. It has a mind of its own.

It needs the boost of confidence. The packaging helps.

Sent: Monday, November 3, 2014 8:36 AM
Subject: My son always

MY SON ALWAYS, aware, attentive, attuned. . . .

I have to watch my inflection, my tone. I cannot lie down or lie back when talking on the phone. The tone changes. Always concerned.

"Are you okay, Mom?"

He reacts for me before he does for himself. Whether it's conversation or upsetting news or even just average breaking news from all over the world. Trying to keep me insulated, keep me from getting hurt. Taking his cues from me, from what he thinks my cues would be before I can come up with them myself. Giving me the benefit of the doubt, the advantage of the better interpretation, watching over me, watching out for me.

My husband, even more protective than he was before. I simply have to be preoccupied, and he worries that I might be "brooding," trying to find ways to compensate and overcompensate wherever he thinks there may be a gap. Constantly looking out for "Mom."

I have to watch what I say. A passing observation is taken to be a desire, and he rushes to fulfill it. I am taken aback at times and have to try to recall what I must have said.

Trying to make me laugh, and laughing off all my mistakes. Nothing is too much for me to ask, for him to give even without my asking

I can only feel more humbled. Do I really deserve this? I can be so short and crabby and difficult. Do I really measure up to all of this? And more?

And our little dog, such silent, loving acceptance of all the changes, all the endless days, months, years? Of simply being, of keeping "Mom" silent company while the men were away during the day.

He took up the baton wordlessly.

Each one of my boys, such complete and selfless giving, accepting, understanding, forgiving.

Always—in all ways. . . .

Making me feel humble and grateful.

I hope I can be a worthy enough "Mom."

I HAVE COME a long way. I'm getting "there." Fingers crossed!

But I am not quite ready, not even ready to use my voice to my comfort, let alone my advantage! I'm not sure what it sounds like exactly, but it feels . . . guttural. Awkward and rough.

Pleasant tones are just as elusive as pleasant small talk.

It's such a task—meeting people, being with them. I can organize the party, but can others do the socializing, the entertaining?

It's not that I don't have my faculties. It's just that I am unable to control them.

Just the other day, I told my husband, "My voice sounds jarring to me. It must sound terrible to others."

He disagreed—loyally!

But he did agree when I said my vocal chords felt weak, like I couldn't control the sound let alone the inflection, tone, nuance.

He seemed to take a long time in replying.

"It was scary," he said finally. "You were just so silent. So still. All the time."

Those couple of years, he felt that he had "lost" me. He's glad I'm "back," of course.

The imp in me is just beginning to relish the idea of reminding him I am.

Nagging him should work!

Epilogue

Sent: Sunday, November 9, 2014 12:34 PM
Subject: It feels like

IT FEELS LIKE breaking dusty cobwebs that blocked me, that I was trapped behind. Tearing them apart and trying to step out.

The pieces cling to me as I cross over, little bits that won't let me go. They stick to my clothes, fibrous and dusty. Not intimidating or overpowering, just annoying.

They won't come off. I have to lift each strand, each dusty fiber. They refuse to let go.

But I am trying to tear apart this huge cobweb. It blocked the entrance to the dark space I was in.

Cavernous and deep. It's difficult to describe as I look back in. . . .

Afterword

Sent: Monday, November 3, 2014 2:56 PM
Subject: Memory can be

MEMORY CAN BE a tacit ally. It shrouds what it feels will be painful and makes indelible imprints of that which gives pleasure.

Sometimes it can be a mischievous imp—here this moment, gone the next. Tantalizing or frustrating, whatever catches its fancy.

It can be a caretaker, keeping moments safe until the dust covers can be removed and their significance exposed.

And an undertaker, boxing up an entire whole. And, burying with it that part of the heart and soul.

About the Author

Ruchi Rai is a proud wife and mother who lives in the Silicon Valley with her husband, Ashutosh, her son, Adhiraj, and their little dog, Ollie.